P9-DGJ-446

ON
DOING
NOTHING

# ON DOING NOTHING

### Finding Inspiration in Idleness

by Roman Muradov

**CHRONICLE BOOKS**

SAN FRANCISCO

Text and illustrations copyright © 2018 by Roman Muradov.

All rights reserved. No part of this book may be reproduced in any form without written permission from the publisher.

Library of Congress Cataloging-in-Publication Data

Names: Muradov, Roman, author.
Title: On doing nothing : finding inspiration in idleness / by Roman Muradov.
Description: San Francisco : Chronicle Books, [2018] | Includes bibliographical references.
Identifiers: LCCN 2017035058 | ISBN 9781452164267 (alk. paper)
Subjects: LCSH: Creative ability. | Inspiration. | Laziness. | Leisure.
Classification: LCC BF408 .M868 2018 | DDC 153.3—dc23
LC record available at https://lccn.loc.gov/2017035058

Manufactured in China.

Design by Brooke Johnson
Typeset in FreightText and Volte

10 9 8 7 6 5 4 3 2 1

Chronicle books and gifts are available at special quantity discounts to corporations, professional associations, literacy programs, and other organizations. For details and discount information, please contact our premiums department at corporatesales@chroniclebooks.com or at 1-800-759-0190.

Chronicle Books LLC
680 Second Street
San Francisco, California 94107

www.chroniclebooks.com

# CONTENTS

# INTRODUCTION

ON THE 9TH OF NOVEMBER 1937, Daniil Kharms wrote the following:

"Today I wrote nothing. Doesn't matter."

He didn't write nothing. He wrote, "Today I wrote nothing. Doesn't matter."

What doesn't matter? The fact that he wrote nothing, or the nothing that he wrote? And if it doesn't matter, why did he write it?

According to legend, in his Petersburg apartment Kharms kept a room filled with wires and bolts. When asked about the mess, he said he was building a fantastical machine that, when completed, would astonish all who witnessed it in action. To the inevitable question, "What does it do?" he replied, "Nothing."

THIS IS NOT a book about not doing anything; it's a book about doing nothing. The difference is in the act: unlike plain indolence, doing nothing is a considered attitude that calls at once for patience and alertness. Its practitioners can be traced across history and geography, and across barriers of language, gender, and class. We can't do much to change our circumstances, but we can do all kinds of mental pirouettes under the most oppressive of conditions.

---

Doing nothing is not a privilege reserved for those whose days aren't filled with work and obligations. We don't need to do much to cultivate idle thought: all it takes is to attune our minds to subtler movements, recognizing their arrivals and translating them into the medium of choice, whether it's a walk in the park or an hour of painting.

Doing nothing is an oddly demanding task, with unsure benefits and obvious drawbacks. Its pursuit is riddled with anxiety, especially in melioristic cultures that value the business of life above life itself. The easier it is to distract ourselves with daily tasks, the more restless we end up feeling in the interims.

There is no reason to do nothing. But then, there is no reason to fall in love, or gather autumn leaves. Life reveals itself most fulsomely in gaps and intermissions.

# 1.

# GET
# LOST

TO GET LOST ON PURPOSE is to abandon all purpose.

That, unfortunately, is as difficult as to "be yourself," "let go," "be in the moment," or follow any such fluffy injunctions, which provide more comfort to the advisor than the advisee. The more we try to be in the moment, the more the moment is obscured. There is no route to getting lost—instead, there is a branching trail of footsteps that helps us lose the way.

In *A Field Guide to Getting Lost*, Rebecca Solnit writes that "one does not get lost but loses oneself, with the implication that it is a conscious choice, a chosen surrender, a psychic state achievable through geography." To get lost in the conventional sense is to fail in finding the predetermined destination; to lose oneself is to set off without a destination, to see the map and the terrain as the primary points of interest.

Without a starting point and a goal, the available space expands into infinity. And if the scale of things is taken lightly, the distance between two corners of a room can be as vast as the distance between two continents.

Commenting on Virginia Woolf's *To the Lighthouse*, Solnit writes: "The dissolution of identity is familiar to travelers in foreign places and remote fastnesses, but Woolf, with her acute perception in the nuances of consciousness, could find it in a stroll down the street, a moment's solitude in an armchair." Anything and everything can serve as inspiration. In addition to her novels, Woolf wrote a number of equally original essays, including "On Being Ill," in which she touches on the artistic potential of influenza, typhoid,

pneumonia, and toothache, proposing an art form to suit each respective ailment: novels, epic poems, odes, and lyrics. The most common experiences are often the most underexplored, and it's a measure of patience and curiosity to find in them something new.

Perhaps the best map for getting lost was imagined by Lewis Carroll in *The Hunting of the Snark*. The character of Bellman describes it as "a perfect and absolute blank." This map, however, is not entirely blank, for it contains the directions of the compass and a rectangular border—elements that qualify it as a functional map.

Carroll expanded this conceptual cartography in his final novel, *Sylvie and Bruno Concluded,* in which a map is made to the scale of the actual land, "mile to mile." From a pragmatic standpoint, such a map presents some difficulties, so instead, the land itself is used as a map. Similarly, Jorge Luis Borges's one-paragraph story "On Exactitude in Science" describes an empire so advanced in the art of mapmaking that the only map that could do it justice is "a Map of the Empire whose size was that of the Empire, and which coincided point for point with it."

Luckily for us, such exactitude is only possible in fiction, and the maps we construct in our minds are destined to be imperfect, and therefore unique. These maps can be detailed or abstract; they may not even look like maps by any given standard. When we set out without purpose, our inner cartographers not only draw their own maps; they also come up with a set of tools, symbols, and signs.

AN HOUR OF WALKING can be seen as study for an hour of writing, while an hour of writing can be seen as a product of the walk.

Every place we visit, for years or for an hour, imprints itself on our minds. Without much effort or intention, we keep refining these mental maps for as long as our brains can manage. In a letter to Bertrand Russell, James Joyce wrote that if Dublin were destroyed by an atom bomb, his novel *Ulysses* could be used to rebuild the city brick by brick. And while this claim is unlikely to be empirically contested, it is safe to say that the rebuilt Dublin would be more than a little different from the actual city. It would be Joyce's Dublin, seen, felt, and walked by Joyce alone. Moreover, every reader of *Ulysses* carries in their head their own vision of Joyce's Dublin, yet another layer of remove, another imaginary city.

Meanwhile, Italo Calvino's novel *Invisible Cities* concerns itself exclusively with conceptual municipalities. The residents of Phyllis, for example, zigzag through their daily routes and ignore the backdrop. "Millions of eyes look up at windows, bridges, capers, and they might be scanning a blank page. Many are the cities like Phyllis, which elude the gaze of all, except the man who catches them by surprise." A place can outlive its lifespan, in history and fiction, or it can crumble under our steps, unless we stop to notice things before they disappear.

Joyce's Dublin and Calvino's Phyllis are built from the same material—the stuff of memories and dreams, and words arranged in an evocative order. Each street we walk dupli-

cates itself in model form, scaled up or down, elaborately painted, or outlined in loose hand. These models can grow detailed with time, or fade into abstraction. When we return to the places of our childhood, our mental routes clash with tangible reality, which asserts itself with a knock on the head from a bit of woodwork that wasn't there before. Perhaps it's time to leave the city and head into the countryside.

W. G. Sebald's novel *The Rings of Saturn* is written as a walking tour of Suffolk, with very few encounters on the way. This modest premise inspires in the narrator a hypnotic

procession of histories, biographies, and inventions, all married in a melancholy, rhythmic lull. Sebald's journey of digressions is rife with links and subtle patterns, but it's up to the reader to connect the narratives. Likewise, Raymond Roussel's novel *Locus Solus* is written as a walking tour of a country estate of unparalleled strangeness. The book entirely ignores the constructs of plot, character, and morality—it reads more like a catalog for an impossible exhibition than a story. Instead of explaining the meaning of his inventions, Roussel allows us a glimpse (albeit an obsessively detailed glimpse) of their workings and lets us reconstruct the rest in our heads. A quiet walk is an opportunity to get lost in the interweaving patterns of our minds and travel to the corners of known and unknown universes without the inconvenience of building a spaceship.

In the last decade of his life, Laurence Sterne wrote an entire novel built on digressions. Published in nine volumes between 1759 and 1767, *The Life and Opinions of Tristram Shandy, Gentleman* remains one of the earliest testaments to the distance an idle mind can traverse, given enough time and paper. Digression can be seen as an attempt at flight from the confines of time; in other words, a doomed attempt at immortality. And, as Sterne demonstrated, digression can also be fun. After a few glasses of alcohol in good company, we often find ourselves surprised at how our conversation moved from country walks to deep-space exploration, and there's no reason why such leaps should not be reproduced in solitude and without drink.

We don't always have time and opportunity to explore each path and alleyway, but we can picture them in our minds, and these imaginary wanderings can circle back into our real lives. Mental journeys take us as far as real ones, particularly if both modes of travel are exercised in unison: thoughts following steps, and vice versa.

IT WOULD BE HIGHLY INAPPROPRIATE, in a book on doing nothing, to neglect the term *flâneur*, from the French *flâner*— stroll, wander, drift.

Charles Baudelaire defines the flâneur as "the passionate spectator." Such a spectator has "to be away from home and yet to feel oneself everywhere at home; to see the world, to be at the center of the world, and yet to remain hidden from the world." Like a private detective investigating the city for the pleasure of the investigation, the flâneur approaches the walk as both the process and the destination. It's not necessarily a search for material; any ideas that may emerge, great or small, are secondary to the walk itself.

As Luc Sante puts it in *The Other Paris*, "the flâneur must be alive to the entire prospect, to the ephemeral and perishable as well as the immemorial, to things that ordinarily lie beneath notice, to minute changes and gradual shifts of fashion, to things that just disappear one day without anyone paying attention, to happenstance and accident and incongruity, to texture and flavor and the unnameable, to prevailing winds and countercurrents, to everything that is too subjective for professionals to credit."

Although the term is defiantly French, the practice can be found elsewhere. Across the channel, Charles Dickens described his aimless wanderings in *Night Walks*, and all the undocumented flâneurs of the world could make up a small army, albeit not a very effective one. The first creature to take a stroll for no particular reason can be called the first flâneur, although we can assume that said creature did not possess the capacity, let alone the need to come up with a circumflexed word. Other cultures and languages found different terms to define the walk, each one reflecting the customs, habits, and emotional weight attached to the act.

The flâneur's territory is distinct to every city, and to every flâneur. The conceptual and emotional worth of a given street is entirely subjective and depends on the interpreta-

tion of a scene as much as on the scene itself. As the flâneur attempts to grasp the city, the city changes with each step; the trendy spots fall out of fashion and become obscure, while unsavory neighborhoods are gentrified into bland attraction. These movements advance in parallel, without a pause—a dance between the city and its inhabitants.

The reason for the near-total absence of women among history's flâneurs is obvious: it was (and, in many places, unfortunately still is) unsafe for a woman to walk alone. Lauren Elkin addresses this issue in *Flâneuse: Women Walk the City in Paris, New York, Tokyo, Venice, and London*: "For as long as there have been cities, there have been women living in them, yet if we want to know what it's like to walk thoughtfully in the city, there is only a long tradition of writing by men that tells us." George Sand, for instance, used to dress as a man to observe the Parisian crowds without drawing unwanted attention to her presence. The flâneur has to remain invisible, to blend in as a "central oyster of perceptiveness, an enormous eye," as Virginia Woolf puts it in her essay "Street Haunting." Something as simple as walking can be a radical act, both for the individual and the society.

TO GUY DEBORD, the author of *Society of the Spectacle*, walking was a form of resistance, an attempt to escape the uniform routes and directions laid out by the Spectacle—his term for the most superficial manifestations of mass media, commodification, and consumerism.

To get away from the Spectacle, Debord came up with the concept of *dérive*. Translated as "the drift," it can manifest itself as a walk through the city, untethered from familiar passages and convenient paths, and instead guided by the emotional currents of the terrain. This allows the walker to explore the borders between neighborhoods and the movements of their residents, the dying and emerging patterns of social behavior.

Thanks to existing and upcoming digital implements, it is increasingly difficult to get lost. Commodification can make our lives easier, but it can also dull the flavor of the quotidian, gradually accentuating its mundanity until every daily experience becomes a chore; checking a digital map when we know the directions, just to make sure, wears out our sense of spatial awareness.

The thrill of aimless drift is thoroughly embedded in our instincts. If we allow ourselves an hour for walking without

purpose, the joy of exploration will show the way. For some, it might outline the benches and awnings; for others, it will zoom in on the anatomy of the terrain. The way we navigate the world is unique to every one of us, whether we're on an evening stroll or a mountain expedition.

THEN THERE'S INDOORS, which is outdoors enclosed with walls, a floor, and, ideally, a ceiling.

We don't need to go far to see the world. We may not even need to leave the room. Franz Kafka, in fact, advised against it: "Remain sitting at your table and listen. Do not even listen, simply wait. Do not even wait, be quiet, still and solitary. The world will freely offer itself to you to be unmasked, it has no choice, it will roll in ecstasy at your feet." Although Kafka is rarely cited in matters of wellness and self-care, the idea that the world will reveal itself to the patient observer suggests that many things occur most vividly in a constricted space. A thrilling adventure provides an excess of stimuli, making it difficult to pick out what's important, while uneventful days tone down distractions and allow us to see the world with greater clarity.

Six times between 1978 and 2000, the performance artist Tehching Hsieh sat in self-imposed solitary confinement for one year, without reading or writing. The reasons behind these performances are open to interpretation, but Hsieh himself defined them as "wasting time and freethinking." To many of us, a mere day spent in seclusion can be unbearable: like any form of social conduct, being alone is both a talent

and a skill. Although artists tend to have a high capacity for solitude, everyone can benefit from confronting their own selves, at least for a short while—after all, the human is a social animal, and it can only aspire to the self-sufficiency of a household cat.

According to Georges Perec, "any cat-owner will rightly tell you that cats inhabit houses much better than people do. Even in the most dreadfully square spaces, they know how to find favorable corners." Over centuries of cohabitation, cats have truly mastered the art of doing nothing, borrowing from their owners the relevant cues and discarding all extraneous movements.

The painter Paul Klee was more than a little fond of his cats. All of them acted as friends, models, and occasional collaborators. On a visit to Klee's studio, the American art collector Edward M. M. Warburg caught a cat walking across an undried watercolor. When Warburg tried to stop the animal, Klee said that the cat should be allowed to wander freely, so that years later, art connoisseurs would wonder how he got that effect. The cat did not intend to collaborate with Klee, and most likely had a limited appreciation of the painting on which it stepped. Klee, however, could appreciate the element of disturbance brought by the cat, and used it in his work. Warburg's account may have a touch of fiction, but that doesn't make it any less true.

In his novel *Wittgenstein's Mistress*, David Markson retells another apocryphal story from art history: Rembrandt's pupils painted gold coins on the floor of the studio, and

these coins were so convincing that the master would stoop to pick them up. What turns these coins into paintings, according to Markson, is Rembrandt bending down. Meanwhile, a cat "would have strolled right past the coins without so much as a glance. Which does not imply that Rembrandt's cat was more intelligent than Rembrandt." A sharpness of focus is as important as a breadth of scope. If we examine the situation through the eyes of the cat and the eyes of the painter, the question of authenticity becomes a question of perspective.

Natsume Sōseki wrote a three-volume novel from the perspective of a cat called *I Am a Cat*. Over the course of the narrative, the artistic, romantic, and professional affairs of the Meiji middle class are ridiculed by the narrator, who

surveys the unfolding scenes with a sly detachment and a supernatural agility; how the cat manages to relate any of these events, including the details of his own death, is never mentioned. Common sense is quietly dismissed in favor of humor and lightness.

Gregor Samsa, the protagonist of Kafka's *The Metamorphosis,* turns into a giant insect. The event is never explained, but underneath the absurd premises and unaffected narration lies an emotional weight that pushes the story beyond pure fantasy. An intrusion of logic would only sour the taste and lead to mental bloating. Likewise, our attempts to interpret such narratives as extensive metaphors for something clear and concrete are just as lazy as taking them at face value. These stories aren't simple puzzles hiding a neat solution. They are intricate constructions, unfolding in a new design for each and every reader, as the world unfolds differently to every observer.

On the subject of metaphors, Kafka had this to say: "Metaphors are one among many things which make me despair of writing. Writing's lack of independence of the world, its dependence on the maid who tends the fire, on the cat warming itself by the stove; it is even dependent on the poor old human being warming himself by the stove. All these are independent activities ruled by their own laws; only writing is helpless, cannot live in itself, is a joke and a despair."

Most of us don't normally talk in metaphors. Having stepped on something unpleasant, we're more likely to voice a monosyllabic exclamation than liken the experience to

something lofty or remote. Metaphors are not exactly necessary, but they can make things memorable, in writing and in daily life.

A metaphor is a detour from the straight path, and few writers have taken these detours as far as Marcel Proust. His digressions often take flight and turn into independent little stories that unhurriedly exhaust themselves of their potential, turn back, and land at the site of departure with a couple of linguistic backflips. This tendency is not exclusive to Proust—we've all experienced these flights, perhaps not always with a publishable finish. Given half a chance, our thoughts veer off the main path and jump from wandering indoors to cats to metaphors to Proust, who, by the way, wrote *In Search of Lost Time* horizontally, from the comfort of his bed.

The sum of Proust's bedridden creativity spawned over 4,000 pages, a number that continues to daunt prospective readers across the globe. Proust was at once a hard worker and a dedicated idler, an astute observer and a patient listener, who knew when and how to take his time (admittedly, his independent wealth did nothing to encumber this behavior).

On top of the seven volumes of his magnum opus, Proust also wrote this short letter to Princesse Clermont-Tonnerre: "My dear Madame, I just noticed that I forgot my cane at your house yesterday; please be good enough to give it to the bearer of this letter. P.S. Kindly pardon me for disturbing you; I just found my cane." This message serves no purpose other than to find humor where the more pragmatic would

only see a waste of time. Digression is the spice of thought, and unlike real spices, the imaginary ones are not confined to the dimensions of jars and cupboards. We can taste and mix them liberally, lying alone in bed and staring at the ceiling, while, inside our heads, daydreams explode the room into a little universe.

ROBERTO BOLAÑO PROVIDED a fitting conclusion to the theme of getting lost in his lecture "Literature + Illness = Illness":

> . . . Kafka understood that travel, sex and books are paths that lead nowhere except to the loss of the self, and yet they must be followed and the self must be lost, in order to find it again, or to find something, whatever it may be—a book, an expression, a misplaced object—in order to find anything at all, a method, perhaps, and, with a bit of luck the new, which has been there all along.

# 2.
# REPETITION,
# DELAY,
# REPETITION

REPETITION IS THE ACT of doing something again, and doing nothing is that same thing, with one small detail removed.

Repetition is defined by delay, and delay by repetition. These alternating elements are familiar to us from school days onward, and, like many things pummeled into a deathly tedium, they require a touch of the unorthodox to show their full potential.

Even the most exciting lives are prone to repetition. Instead of exerting ourselves to avoid these patterns, we can embrace them in both their uniformity and uniqueness. This chapter is the longest in the book, which is in no way due to lazy editing. Rather, it's a reflection of the breadth of the subject and its innumerable manifestations.

Remembrance and reenactment, homage and plagiarism, study and subversion, rewriting and translating, repetition and repetition—all these threads can be pulled out and woven into new patterns, always different, always the same.

THE HISTORY OF ART is the history of repetition.

Between 1892 and 1894, Claude Monet made more than thirty paintings of the Rouen Cathedral from the same spot across the street. Almost all of these canvases display the same perspective and composition. They differ chiefly in the study of light—which informs not only the colors, but also the subtle shifts in treatment—and, inevitably, the artist's mood, transcribed in the paintwork as in a cardiogram.

Yayoi Kusama has applied her signature red dot patterns to the entire spectrum of artistic expression, from sculpture and paintings (on canvas and on living beings) to performance art and environmental installations. The recurring motif doesn't make the work repetitive; it transforms each chosen medium, allowing the viewer to reconsider it through

the screen of Kusama's polka-dotted vision. Reduced to minimal components, each medium becomes an active participant in the work.

When not repeating themselves, artists tend to repeat others. While working on her translation of *Madame Bovary*, Lydia Davis read Gustave Flaubert's extensive correspondence and rewrote parts of it as short stories, which she included in her collection *Can't and Won't*. The same collection includes pieces marked as "dreams," some of which are inspired by actual dreams, and some of which are real-life incidents written in the manner of a recounted dream. In an interview with *The Paris Review*, Davis said, "I think it's hard to draw the line and say that something isn't found material. Because if a friend of mine tells me a story or a dream, I guess that's found material. If I get an e-mail that lends itself to a good story, that's found material. But then if I notice the cornmeal making little condensations, is that found material?"

Authorship aside, the use of such material is a form of artistic repetition. Adapting the existing stories into our own forces us to reconsider the appearance and meaning of the source, and, in the process of repetition, give it a different context.

Yoshihiro Tatsumi would go through police reports and newspaper items to find material for his comics, portraying the desperate and lonely lives of ordinary people in postwar Japan with unflinching realism, rare for the manga of the time. His characters are often quiet, anonymous stand-ins,

informed in their behavior by the voice of the reports—detached and dry, with minimal detail.

Barry Murphy and Mark Doherty took the Polish soap opera *Pierwsza miłość* (First love), edited it into short fragments, and redubbed them into English under the title *Soupy Norman*. Their version has little to do with the original, save for the borrowed footage: it becomes the story of a young woman from Cork leaving her mildly demented family to seek her fortune in Dublin. The new characters cling to incidental details from the original footage to gather cues for their dialogues and dramatic pauses, and the generous amount of Irish vernacular lends the show a distinctly surreal turn. Soupy Norman himself appears in a single sequence, repeated eight times: he stumbles at the door, clearly drunk, mutters a few inanities, and retreats into the night with a piercing shriek. The show relishes the awkwardness of the concept, pushing the story into ever stranger territories with a mixture of guesswork and absurdity.

Tim Hensley adapted a Xeroxed accusatory rant from an ex-bank employee into comics, setting the strangeness of the found text against the garish gradients of newspaper strips. For the idea to function, Hensley had to study the ugliness of the material in order to mimic it well—a master study doesn't have to involve a master.

Flann O'Brien once received a letter from a racing tipster, and plugged it into his novel *At Swim-Two-Birds*. The book is a delirious kaleidoscope of narratives and styles, brimming with direct and subtle references to works outside and inside

its universe. In the course of the story, the author's erudition and humor go hand in hand into a dark, dense wood and proceed to have a metafictional orgy on an as-yet-unsurpassed scale. O'Brien's narrator, a fiery proponent of doing nothing, declares from the start that "a good book may have three openings entirely dissimilar and inter-related only in the prescience of the author, or for that matter one hundred times as many endings." The same applies to any medium—the pigments on a canvas regroup each time the painting is reframed, or shown in a new setting.

In 2012, Monet's *Argenteuil Basin with a Single Sailboat* was punched at the National Gallery of Ireland for some uncertain reason. The assailant was sentenced to five years in jail, and a team of conservators was assembled to restore the painting to its original state. First they examined it under a microscope to reconstruct Monet's process, starting with the paint itself. Then the threads of the canvas were restored one by one, following the outlines of the tear. Finally, over a hundred tiny fragments of the painting were reinserted, as in a jigsaw puzzle, with gesso filling in the gaps and eventually painted to match the original as closely as possible.

This case can be seen as an unintentional study in repetition: Monet invests his life in perfecting his art, relying only on his skills and observations to see familiar sights anew. A man punches one of these paintings, and in a second, unwittingly drags it into postmodernism, which is then effaced through a painstaking process of restoration that, in its turn, reveals new details about Monet's approach. In

the end, there are at least three versions of the painting, and their precedence is left for us to rearrange. After all, if the painting is punched again by another man, the first one may well complain of plagiarism.

EVERYTHING HAS BEEN DONE, so it's worth doing it again, differently.

Luckily, it's not that difficult—in fact, it's much harder to do the same thing twice. Unless copy-pasting is involved, we have no choice but to express ourselves. In *Tradition and the Individual Talent*, T. S. Eliot describes poetry as "not the expression of personality, but an escape from personality." In this escape, poetry does not become anonymous; it expresses the author regardless of their will, even when the author is blatantly copying somebody else. Eliot himself borrowed and recycled a great amount of material in *The Waste Land*, from seventeenth-century epic poetry to pop hits of his time.

For her song "Anaconda," Nicki Minaj truncated a well-known refrain from Sir Mix-a-Lot's 1992 single "Baby Got Back" and sampled it into a different shape. When asked his opinion, Sir Mix-a-Lot enthusiastically praised Minaj's vision, particularly "the change in feel." Through its explicit sampling, "Anaconda" becomes more than a cover version; it transcends the decade-old euphemism (which sounds rather coy next to Minaj's unrestrained lyrical contribution), and changes the way the old song is perceived.

It's often hard to tell where homage ends and plagiarism begins. These questions call for an attitude of constant

inquiry, as well as a considered artistic intent. Treating the present as an outgrowth of the past allows us to steer away from indolent appropriation. With understanding and respect, a direct reference or even a copy can accomplish much, while a mindless imitation can be disrespectful or downright offensive.

Miguel de Cervantes had no qualms about sampling his own work. Since the two parts of *Don Quixote* were originally published ten years apart, every character in the second part of the book had time to read the first. Jorge Luis Borges took these echoes even further in the character of Pierre Menard, a fictional twentieth-century writer, who inadvertently writes an exact copy of the seventeenth-century *Don Quixote*. According to Borges, Menard's version is a significantly richer text, due to the time that separates the books, and its historical distance.

When we consider all the factors that influence our life and work, it's virtually impossible to repeat what has been done. When we ignore these factors, banality and clichés

abound; in the pursuit of the new, old patterns reemerge. To avoid repeating ourselves, we can try and fail to repeat others.

In *One-Way Street*, Walter Benjamin writes, "The power of a country road is different when one is walking along it from when one is flying over it by airplane. In the same way, the power of a text is different when it is read from when it is copied out." The best way to study a work of art is to copy it, and copy it openly, with the single-minded dedication of a dog chasing its own tail. Inevitably, the copy will have imperfections—the sum of these imperfections is style.

THE ACT OF NOT MAKING ART is just as valuable as the act of making art. Delay can inform the work that is to come, or give existing work a different meaning.

Perhaps the artist most famous for not making art is Marcel Duchamp. Never exceedingly prolific, Duchamp seemed to have retired from art entirely in the last decades of his life. This proved to be not quite correct: from 1946 until 1966, he worked in secret on his final piece, which was revealed to the public a year after his death. As for his last words, Duchamp saved them for his tombstone: *D'ailleurs, c'est toujours les autres qui meurent* ("Besides, it's always other people who die"). In keeping with his irreverent body of work, the inscription is a joke, and one that can be told indefinitely, but only in the absence of the teller.

Jonathan Monk's photographic series *Waiting for Famous People* shows the artist at the arrivals gate of an airport holding signs with names like Elvis Presley, the Queen, and

Marcel Duchamp. Monk revisited this airport performance ten years later in fitting tribute to Duchamp's philosophy of delay. Repeating oneself after a long while can have a strange distancing effect, as the work we revisit feels like it's no longer ours, as if another Pierre Menard had something to do with it. Artistic delay is resisting the impulse to explore an idea fully at its birth, instead allowing it to live for a while in the greenhouse of the mind, where it may mature and corrupt, grow into something new, or die and fertilize the soil.

Considering the number of hours we spend in literal or metaphorical waiting rooms, time is not in short supply. These periods add up to a decent stretch of emptiness that we can dedicate to the minutiae of life, or to the outlines of our projects.

Waiting rooms aside, here are a few other places fit for doing nothing:
- the corridor
- the bathroom
- the bus
- the street
- the park
- the outside
- the airplane
- the airport
- the train
- the elevator
- the bench

- underneath a cat or a similarly sedentary animal
- the garden
- the grave
- the grocery line
- the horizon line
- the conga line
- the void

Without due consideration, a delay can claim all given time and space. Jean-Philippe Toussaint divides his artistic process into two states: patience and urgency—both of them working together despite their contradictory nature. Whatever our opposing principles may be, we can develop them in parallel, but not in confluence: a palette of black and white is sharper than a palette of gray.

While it's easy to sway towards one extreme or another, holding both at the same time is a balancing act that keeps the artist constantly alert and aware. In *Six Memos for the Next Millennium*, Italo Calvino pairs each of his literary values with its opposite, since one is meaningless without the other. Lightness relies on heaviness. Heaviness relies on lightness. A flash of inspiration would lose much of its luster without the wait that precedes it.

In keeping with Calvino's idea, we can't examine delay without acknowledging immediacy. One of the exercises Ivan Brunetti suggests in his book *Cartooning: Philosophy and Practice* is drawing the same face a hundred times, one after the other. This exercise is focused on exploring and developing a visual vocabulary, as well as drawing skills. In a row of

identical faces, the smallest variations can speak volumes, and the nature of the resulting inconsistency can help us understand our proclivities and quirks.

The critic Vivian Mercier famously described Samuel Beckett's *Waiting for Godot* as "a play in which nothing happens, twice." The statement can be seen as a criticism, but it can also be seen as a compliment: writing a second act that mirrors the first without sending the audience to sleep is no small achievement. Forcing ourselves to repeat ourselves can hint at new solutions to familiar puzzles, or cast the previous solutions in a new light.

In 1998, Dominique Goblet (aged 31) and her daughter Nikita Fossoul (aged 7) decided to draw each other on a regular basis. Ten years later all these portraits were collected and published as *Chronographie*. The book is a tribute to the passage of time, growth, and experience, to the fleeting sensations that both mother and daughter captured and let slip. It has the lightness of each moment, as well as the weight of the years it took to complete. No time is ever truly wasted.

A delay allows us a better appreciation of our practice, and a better understanding of our surroundings. It's also a good way of learning patience. After embarking on a brief (very brief) artistic career, Tove Jansson's Moomintroll declares that all he wants is "to live in peace, plant potatoes and dream." Having said that, with a plump beret draped over his head, he takes a few steps and falls off a cliff. The pursuit of art in any form requires tremendous patience, as

well as the willingness to put the tools aside, instead of stubbornly persisting onward.

In his graphic novel *Arsene Schrauwen*, Olivier Schrauwen instructs the reader to put the book aside after reading each of its parts: first for a week, then for two weeks. Whether the reader follows this injunction is beyond the author's control, but these intervals can lead to a more involved reading experience, as names and details fade from memory, and the novel's patterns increasingly grow faint. A measured reading becomes a collaboration between the reader and the book, whether the book tells us to stop or not.

In 1967, just as her work was beginning to receive widespread acclaim, Agnes Martin left her New York studio, gave away her supplies, and didn't paint for seven years. During that time, she traveled in New Mexico and in Canada, the country of her birth. In 1974, she returned to the art world, abandoning her trademark grids for vertical stripes, and muted chromatic colors for lush and vivid tones. The reasons behind Martin's journey are hidden in the paintings that followed the delay. In a rare interview with *ARTnews* in 1979, Martin said, "We all have the same inner life. The difference lies in the recognition. The artist has to recognize what it is." Sometimes that recognition can take an awful lot of time.

At the time of her departure, Martin was 55. She completed her last painting at 92, a few months before her death. Carmen Herrera was 80 when she sold her first painting, after decades of prolific and inventive work. Bill Traylor made his first drawing at 85, while Arthur Rimbaud stopped

writing at 21. The artistic timeline is distinct for all of us and can't be seen in full until the artist is no longer present.

ALL WORKS OF ART address their own conception.

In the case of Robert Morris's *Box with the Sound of Its Own Making*, the process literally is at the heart of the piece, which is a wooden box containing a 3.5-hour recording of the sounds emitted during its construction. Although the exhibited box appears complete, the soundtrack is looped in endless incompletion.

The poetry of Sappho has survived only in fragments. In English, these unfinished lines are rendered differently depending on the translator: some choose to preserve the gaps in the manuscript, while others arrange the words to

flow in a succession. We can imagine what Sappho wrote between these lines, or we can appreciate the lines on their own, separate from their historical and literary context.

A snippet of a conversation can take us further in our mental flight than the same conversation heard in full. Anything we encounter can be considered unfinished. There's always something hidden beneath the surface, whether the author intended it or not. Retracing the creation of the piece allows us a glimpse of the author's design, the process, and the inspiration.

An unfinished piece hints at a multitude of possibilities, while the term "finished" is merely a label set by the artists and their clients. Aram Saroyan's poems often amount to a few unpunctuated words, at least in type. When read with due attention, however, a poem is more than the sum of the printed words; it's also the spaces between the lines and words and everything that acts as insulation.

With this approach, the gulf between creating and consuming is not that vast, and can be bridged without a strain on the hip flexors. Every work of art we meet replicates itself in our perception. Seeing and hearing can be as creative as painting and singing.

READING IS A WAY OF SEEING, and seeing is a way of reading.

It's hard, if not impossible, to find a good writer who is not a good reader. Reading is more than deciphering words into messages. It's an artistic skill, no different from any other. As such, it requires work, rather than the mythical

substance known as "talent." Although some people (predominantly uncles) have an irritating tendency to ascribe artistic brilliance to inborn gifts, those involved in any creative practice will readily dispel this misconception.

A book skimmed through at lunch will leave a different impression than the same one savored in the evening. There's nothing wrong with multitasking, especially when the meal is a mere source of nutrition and the book is something of a bore. Still, even an hour of dedicated reading can be a rewarding and memorable experience.

The time we devote to other people's art is just as important as the time we devote to our own. What's more, revisiting familiar pieces gives us a deeper understanding of their ideas and craft. According to Vladimir Nabokov, "a

good reader, a major reader, an active and creative reader is a rereader." Considered in a wider sense, the act of reading and rereading can apply to every medium. At no point in time is any work of art exhausted of its value.

This attitude extends beyond the realm of art. All of us have reread our experiences, in dreams and involuntary memories, as well as in conscious thought. The most repetitive daily ritual can be a source of inspiration, if we examine it up close, and note the shifts and deviations.

ART IN TRANSLATION is art as translation.

Nabokov rewrote and revised his memoir *Speak, Memory* numerous times, for both the English and Russian versions. The book's protracted birth attests to the endless permutations of human memory, even when it comes to our own lives. Yoko Tawada's novel *Memoirs of a Polar Bear* features the theme of translations both in the plot and in the way it was conceived: Tawada wrote the novel in Japanese, then translated it into German. The process and the narrative become intertwined and codependent. For the English edition of the book, Tawada asked her publisher to work from the German version, to ease the transition from one Western language into another. Samuel Beckett, on the other hand, having mastered English under the weighty shadow of James Joyce, chose to write in French, in order "to be ill equipped." With one exception, he translated all of his books into English himself, thus returning to his mother tongue through a detour of his own design.

Jorge Luis Borges outlined two types of translation, one through literal interpretation, the other through paraphrase. One reaches for exactitude, the other turns to substitution.

Either way, the concept of translation can be applied beyond the medium of text: a painting inspired by a poem, for instance, can be seen as a translation. An artist who draws inspiration outside their medium has more room for invention. The greater the distance between the source of inspiration and the resulting expression, the more original that expression tends to be.

César Aira illustrated this point in his novel *The Literary Conference*. According to its narrator, our originality is in direct proportion to the diversity of books on our reading lists—we can trace our favorite authors in their influences and stop there, or we can read something entirely at odds with our taste. To take this further, a painting inspired by a

poem can turn out more original than a painting inspired by another painting. We don't even need to make art in order to feel the benefits of this approach—our daily decisions can be rooted in the last book we read, rather than in our opinions and expertise.

For the sleeve notes of *The Black Saint and the Sinner Lady*, Charles Mingus asked his psychotherapist, Edmund Pollock, to write a review of the record. Having no expertise in musical criticism, Pollock submitted a psychological analysis of the musician's history and identity gleaned from the compositions, rather than a sober assessment of the artistry at work. Mingus wasn't afraid to experiment, in composition and beyond, and the sleeve notes went down in music history, along with the album itself.

Exposing ourselves to a wide range of styles and media across periods and cultures can be both confusing and empowering. It forces us out of our comfort zones and prevents us from being pigeonholed by algorithms of taste prediction. It's tempting to hide in bubbles of given density and size, and limit our scope to what appeals to us and complements our intelligence, but that attitude can narrow the horizon and evolve into placid mediocrity or full-blown ignorance. We can view the events in our lives as an extensive collection of fictions by various authors, some of them comfortingly familiar, others confusing and often unpleasant. To read them all without discrimination is to learn from the entire library, instead of snuggling up between a pair of shelves.

The worst clichés can be reexamined in a new light and subverted through language, irony, and dissonance. In the olden days, it was common for a writer to address their dear reader in a manner that eventually appeared jarringly out of style. Christine Montalbetti, however, employs this dated technique in the twenty-first century, inviting the reader to participate in a dialogue with the text, rather than blindly follow the narration. Her novels are constantly aware of the medium and its limitations, and question the established form, instead of accepting it out of adherence to tradition and habit.

Reality can be in direct opposition to the work it inspires. In an interview with the *Guardian*, Jenny Erpenbeck said, "I like it when the material and the story you have in mind don't fully match up: it forces you to think more thoroughly." Her novel *Visitation* connects decades of history with the lightness afforded only to works of fiction. The narrative voice stays close to the events in style and choice of words, while relaying them with the hindsight of contemporary knowledge. According to Erpenbeck, this method allows her "to think outside the currents of time." An awareness of historical events informs our work, even when these events are not explicitly related.

To think outside the box, we should first explore the box, and do it thoroughly. Likewise, to turn away from a given field, it doesn't hurt to study and master that field first. Still, it doesn't have to sound so glum: while serving time in the medium of choice, we can simultaneously look to all sides

for the first opportunity to desert it. What's more, we don't even need to switch media or languages to challenge ourselves; we only need to see them from afar. For that purpose, a stepladder will work just as well as a mountain—and confining the surveyance to mental terrains allows us to save on stepladders and mountaineering equipment.

If we manage to step outside our viewpoint, the scenes of daily life can be translated into a different perspective. It's hardly possible to see ourselves from the outside, but a slight shift in misunderstanding can lead to better understanding.

ART BEGINS AND ENDS with miscommunication.

In his later years, Robert Walser produced a vast number of coded stories on tiny scraps of paper, which were eventually deciphered and published as *Microscripts*. Many of them

were lost or discarded by the author, who wrote these stories with no publication or readership in mind.

Of all the texts produced so far by our species, the amount intended for artistic appreciation is nominal. The texts designed to pass on information make up another segment of the chart, and the final bit contains the texts displayed for no discernible reason other than the conveyance of words.

In Russia of the 1980s and '90s, a typical elevator was a living palimpsest of modern folklore, inscribed from top to bottom with trivial insults, lewd poetry, band logos, the ubiquitous "rap cool" and "Kurt Coban is lives" [*sic*, both], and well-meaning but mostly insensitive warnings about a neighbor's venereal disease, interspersed with correspondence about the implicit values of the present regime. As lengthy as these writings sometimes were, it's hard to imagine someone taking an elevator for the express purpose of sharing their reactionary views. These messages were written in moments of elevated idleness, addressed to no one, with minimal self-censorship, and for no reason. Eventually they were wiped away, replaced with forums and chatrooms, and exiled to our collective memory. But the need to write words, to repeat and refute them, is inherent in our consciousness. Artistic or communicative forms serve only to contain the verbal effluence, to frame it in a semblance of meaning.

Anne Carson experiments with these notions in her translation of a fragment from Ibykos, a Greek lyric poet

from the sixth century BC. Instead of providing a single version, Carson translates the text six times, borrowing words from "Woman's Constancy" by John Donne, *Endgame* by Samuel Beckett, stops and signs from the London Underground, and an instruction manual for a microwave. In her approach, Carson draws no line between literature and ephemera, and the position of her brow is neither high nor low, and certainly not in the middle—it fluctuates unrestrained, avoiding clear definition.

In a moment of anxiety and unease, it often helps to write out all our troubling thoughts on the nearest scrap of paper. Once the whirlpool of words calms itself into a puddle, we can throw away or ritually dispose of our writing. This can be a simple way of airing the unutterable without causing distress to those around us, or it can hint at something larger than the problem at hand.

Language is not a mere means of communication. It's more than that, and often it's not even that. What exactly do we communicate when we talk to ourselves, in silence or out loud? It can be many things, or nothing much at all. What's more pertinent is the shared need to give our thoughts voice, shape, and color. This kind of rhetoric is accessible to all, but it takes a bit of patience and self-reflection to hear the words and see behind the force of their enunciation.

THE BEST THING ABOUT MEMORY, at least from an artistic perspective, is that it doesn't work particularly well. Each act of remembering is not a replay, but a reenactment.

The past is a fiction. As such, it is subject to all attendant clichés, like the one about the past being a fiction. As Gaston Bachelard puts it in *The Poetics of Space*, "our past is situated elsewhere, and both time and place are impregnated with a sense of unreality." This unreality accounts for contradictory memories and for the artistic potential that comes with them.

Following the theft of thirteen artworks from the Isabella Stewart Gardner Museum, Sophie Calle interviewed the curators, the guards, and other members of the staff, asking what they remembered about the missing pieces. Their responses form a tribute to individual and collective memory—an invisible museum in which the paintings still hang in countless permutations. We all have such museums, whether they're kept private or open to the public, with or without admission fees and student discounts.

WHEN EXERCISED without due contemplation, repetition can have a numbing, desensitizing effect on the mind.

The concept of incremental progress is a comforting one, and as such, it can be both helpful and obstructive. Drawing every day does not make us better artists—it makes us better at drawing. Without a pause, we have no time to stop and study the effects of repetition.

When *Seinfeld* became popular after a few seasons, the studio audience began to cheer the appearance of any familiar character. As a result, precious seconds were lost from the show each time the wacky neighbor Kramer burst through the door (which he did regularly). Eventually, the show's co-creator, Larry David, forbade the audience from applauding an entrance, which allowed the cast to get on with the script.

We get easily attached to what has previously affected us. While perfectly natural on its own, this attachment can cloud our judgment of both the unknown and the familiar. The latter can become an addictive source of short-term comfort, even when we have fallen out of love with it.

Repetition can be mind-numbing, but it can also be a catalyst for experimentation. The difference is in the treatment—with a considered approach even boredom and plagiarism can become powerful artistic techniques.

The longest part of Roberto Bolaño's novel *2666*, called "The Part about the Crimes," documents the murders of 112 women in the fictional town of Santa Teresa. The narrator relates these murders in an uncharacteristically detached,

impersonal style. Over the course of almost 300 pages of insistent repetition, boredom becomes a source of disturbance and, by degrees, incriminates the reader. Bolaño uses repetition to inspire a greater sense of awareness through the nature of the medium itself, rather than spelling it out in a direct statement.

George Herriman recycles the premise of a love triangle among a cat, a dog, and a mouse in almost every single installment of his comic strip *Krazy Kat*. The cat is in love with the mouse. The mouse throws bricks at the cat. The cat, in the delirium of love, mistakes the bricks for signs of affection. The dog, who is in love with the cat, arrests the mouse. The cat refuses to see the mouse as a criminal, and so ignores the dog and pines for the imprisoned mouse. Yes, it is rather complicated. Over the course of thirty years, Herriman postponed their relationship from any resolution through endlessly inventive wordplay, design, and storytelling. What in less capable hands would be a narrative dead end becomes an inexhaustible source of inspiration.

Clarice Lispector summarized Marcel Aymé's two-part story on the subject of wine and called her version "Two Stories My Way." Recounted in her style, the story becomes a different story. Likewise, the same story told by the same person on a sunny day and on a rainy day is a slightly different story. We can barely pass along the simplest bit of news without adding to it our own interpretation, or, in other words, rewriting it. The network of fiction surrounding our daily conversations extends beyond the scope of any

library. The more we repeat these stories, the further they stray from the source, and the more our narratives expand in richness and complexity.

STYLE IS SUBSTANCE.

Raymond Queneau wrote ninety-nine versions of an exceptionally mundane anecdote about a minor altercation on a Parisian bus, a missing button, and a hat. Each iteration is written in a different style: abusive, biased, tactile, visual, olfactory, in spoonerisms, in free verse, as a dream, as a sonnet, and even as an ode.

These little stories were eventually published in France as *Exercices de style* (*Exercises in Style*). Despite, or perhaps because of the unusual nature of the work, Queneau wanted to see the book translated into other languages. For the English edition, Barbara Wright replaced the styles specific to French with exercises of her own, including Cockney, Gallicisms, and Opera English.

In 1960, Queneau and François Le Lionnais formed OuLiPo (short for *Ouvroir de littérature potentielle*, or

"Workshop for potential literature"), in order to escape the trappings of inspiration through the use of constraints. These constraints can be simple or complex, or simple in concept and complex in execution, like Georges Perec's *La disparition* (translated by Gilbert Adair as *A Void*). The novel is a lipogram in twenty-six chapters, written entirely without the letter "e," the most common vowel in the French language. In a testament to Perec's ingenuity and skill, one reviewer famously managed to read the entire book without noticing the omission.

A constraint is more than a mere exercise in linguistic versatility. In the process of untangling, it can move into more emotional territories, and it can propel the central concept, as in Anne Garréta's *Sphinx*, a novel written without any pronouns. This constraint allows the author to explore the role of gender in society by imagining a world where that concept is entirely absent.

Perhaps the most ambitious OuLiPian novel is Perec's *Life A User's Manual*, an encyclopedic dissection of a Parisian building written in a series of constraints too numerous to list here in full. At the heart of the book, however, is a relatively straightforward exercise in futility, a lifelong project devised and executed by one Percival Bartlebooth. Here's a loose outline of his plan:

1. To learn the art of watercolor.

2. To travel the world and paint 500 ports.

3. To have the 500 watercolors cut into jigsaw puzzles.

4. To solve each of the puzzles.

5. To restore the puzzles into original watercolors.

6. To send each watercolor to the place of its origin, where each one, on the twentieth anniversary of its painting, will be effaced into a blank sheet of paper.

According to the plan, the result of this fifty-year project would be a stack of blank papers. Of course, things don't go quite as planned, and Bartlebooth dies before he can complete his task, leaving behind him traces of his life and art, scattered like fragments of an unsolvable puzzle.

Our lives are defined by the futility of our endeavors. Perec's methods celebrate this futility, instead of rejecting or ignoring it. At a cosmic scale, everything we do is terrifyingly pointless. Piling up constraints and puzzles does not simply cover up the void; it gives shape and warmth to what would otherwise be hollow.

Everything is constrained: this book, this page, this paragraph, this word. An awareness of these constraints can reveal a new way out of the maze, even if that way involves expanding the maze beyond the original design. And it's not just writing that benefits from being forcibly constrained. A similar *ouvroir* has been spun for every other art form, from OuBaPo (comics) and OuGraPo (graphic design) to OuHisPo (history) and OuCuiPo (cuisine).

WHEN WE BLUR THE LINES between life and art, both can be a little more enjoyable.

A common artichoke provides an edible metaphor for any creative practice. The journey to its heart is an unhurried and repetitive sampling of minor delights and bitter disappointments. At the end, we're left with a pile of discarded leaves as large as the fully-clothed thistle, if not larger. And yes, we could cut the artichoke, but then we'd have to split its heart in two—great for roasting, confusing for metaphors.

Peeling an artichoke leaf by leaf can be a source of comfort, but cooking can be more adventurous, or creatively constrained. Madame Moreau, a character of Perec's, entertained her guests with an assortment of conceptually

colored meals. A visitor from the USSR, for instance, would be treated to a red dinner of salmon roes, cold borscht, crayfish cocktail, fillet of beef carpaccio, and salad of three red fruits. Inventions of this sort are best left to certified chefs and fictional eccentrics, but even the most common meals can acquire an artistic depth when taken with a playful spirit.

Among other things, Perec composed an autobiographical piece under the self-explanatory title "Attempt at an Inventory of the Liquid and Solid Foodstuffs Ingurgitated by Me in the Course of the Year Nineteen Hundred and Seventy-Four." Despite a total absence of stylistic flourish, Perec's attempted inventory reads like a poem in prose, as well as a shopping list, featuring, among other things, four artichokes and a prodigious amount of wine and cheese. Sometimes noting the patterns is all it takes to make daily life exciting.

A sudden break from familiar cuisine can be a memorable occasion, while a diet of endless extravagance can gradually dissolve into ambiguous mush. A mindless pursuit of new experiences can only further our sense of boredom. It doesn't take much to be taken by the extraordinary, and it's much harder to find inspiration in the everyday—still, it's worth the effort: not only does the everyday become more palatable, but new experiences also become acutely felt when we approach them with a sharpened perception.

INNOVATIONS ARE often rooted in accidents. And while everyone makes mistakes on a regular basis, it takes curiosity and wit to treat them as artistic tools.

As a young man, Samuel Beckett installed himself as an assistant to the increasingly iritic James Joyce. According to Richard Ellmann's biography *James Joyce*, once or twice Beckett attempted to write down parts of *Finnegans Wake* under dictation. On one such occasion, there was a knock on the door, and Joyce answered, "Come in." Beckett didn't hear the knock and wrote Joyce's response as part of the manuscript. Later, when the confusion became clear, Joyce told Beckett to keep this accident in the novel. The details of this anecdote have been called into question, but, as in the case of Paul Klee and his feline collaborator, this story is remembered for its artistic truth, rather than the factual one.

While listening to a rough mix of the song "Paintwork," Mark E. Smith of The Fall accidentally pressed the wrong button and recorded a bit of TV playing in his hotel room. Instead of fixing the mistake, Smith left it in the final mix, including the sound of the button being pressed. The accident fit perfectly among The Fall's cryptic lyrics, in which highbrow references and surreal details are indiscriminately mixed with advertisement slogans.

For an artist, the word "mistake" betrays a needless judgment. It is categorical and blunt and has little significance, considering how frail the standards of success can be at any point in time. Yesterday's mistakes become today's masterpieces and tomorrow's clichés.

In *What It Is*, Lynda Barry examines two questions familiar to anyone who's ever attempted to make anything: "Is this good? Does this suck?" To escape these questions, Barry proposes that one should "be able to stand not knowing long enough to let something alive take shape." This attitude is helpful in the beginning of the process, but it can be just as important to question and edit our work.

Failure is often viewed either as a mark of mediocrity or a necessary step toward success. Both outlooks can be equally pernicious. Failure is a construct that isn't out of place in certain settings, such as classrooms and canoe races—applied to other aspects of life and art, the idea of failure can impose judgment where it's not particularly needed.

The morbid adulation of failure is just as bad as, if not worse than, the fear of failure. The former depends on

eventual success for its existence, depicting the failure as a step in a linear narrative. Without a happy ending, the narrative is rather grim. Although unhappy endings mark the majority of human ventures, they rarely find their way into motivational speeches, unless a redemptive comeback is hidden in the postscript. If both success and failure are removed from the conversation, all that remains is the work.

Learning from mistakes can be the ultimate reward. Failure is just one part of the process, neither more nor less important than the other components. Viewed alone, a failure is a failure. With distance and time, however, we can see it as a detail in a pattern that reveals itself only at a larger scale.

HOW DO WE DECIDE what should be left in and what should be left out?

According to Peter Turchi, we cannot know the answer to this question "until we know what it is that we're making, toward the end." This uncertainty shouldn't be discouraging, since it pushes our methods forward. If there were a universal, foolproof guide for achieving artistic excellence, there'd be no need to bother making art.

Planning ahead, with enough room for improvisation, can help us retain a sense of discovery throughout the process, rather than only at the start. At the same time, careful editing is just as important, even when its effects cannot be seen.

If the first draft is perfect, the choice to leave it untouched is still an artistic decision. A chain of revisions that leads back to the first draft is not a waste of time; these revisions allow us to explore areas that we may bring back at a later point, for a different project, possibly even in a different medium. Writing is rewriting, and rewriting is writing.

More often than not, our first drafts are not perfect. A good way to approach the ordeal of self-editing is to spend a good while doing nothing. The length of the while is often determined by deadlines, but ideally the artist should be given enough time to forget as much of the work as possible. There are benefits to starting early, and there are benefits to procrastination, so why not do both? We can write down the first ideas immediately, let them simmer, then reappraise them from a matured perspective. This approach is particularly useful for a project that involves research—once we're

well acquainted with the subject, it can be hard to remember what it was like to encounter it for the first time. After a delay, our first draft will remind us of those initial impressions and bring us closer to the perspective of our audience.

A FEW WORDS on the subject of procrastination.

Our willpower and attention spans are limited, and although they can be exercised or forced into compliance, it's worth acknowledging our limits and massaging them when the brain is willing to go an extra mile (or any other preferred unit of linear measure).

Humans have a boundless capacity for wasting time. Freeing up a week for a specific project inevitably puts pressure on the artist, and the regret of wasting that week can crush the strongest spirit. Instead, it can be helpful to keep expectations adequate and the task list short.

Artists of a more lugubrious disposition may dismiss the comforts of idleness as incompatible with the pain and suffering of true art. Nonetheless, a long-term artistic pursuit, whether professional or amateur, is so demanding that allowing ourselves time to be unproductive is not a luxury, but a necessity.

MECHANICAL REPETITION does not devalue human repetition.

Matmos's album *Ultimate Care II* is composed entirely from the sounds made by the washing machine of the same name, either in its intended functions or as "an object being rubbed and stroked and drummed upon and prodded

and sampled and sequenced and processed." Iggy Pop was inspired by the intense, monotonous noises he heard coming from the nearby Ford Motor Company, and these sounds found their way into his early records with The Stooges. The young Maurice Ravel visited a number of factories in the company of his father, who had a penchant for introducing his children to the marvels of technology at an early age; one of these factories recurred in Ravel's vision for the stage design of *Boléro*. This piece is considered his most straightforward composition, consisting of two melodies repeated in a gradual crescendo, and set to an unchanging rhythm, not unlike that of mechanical reproduction. However, *Boléro* is not played by machines. It relies on human performance for its urgency and depth.

Jon McNaught dedicates entire pages of his comics to leaves rustling in the wind, grass being mowed, birds and airplanes taking off and landing. The difference between two identical drawings of a leaf can be minimal, at times almost nonexistent. Still, the difference is there, and the reader feels it, often before their eye has a chance to spot the inconsistencies. Were McNaught to copy-paste these elements, the exact same sequences would lose a great deal of their charm.

The main drawback of digital tools is the presence of the Undo button. Even if used in moderation, it removes the risk inherent in committing marks to paper. And without risk, there are fewer opportunities to make mistakes, and to learn from them. Drawing the same thing twice can double

the potential for variation, and make us more aware of our weaknesses and strengths.

From 1966 until the end of his life in 2014, On Kawara produced more than 3,000 paintings in the *Today* series. Each canvas depicts the date on which it was made, in white-on-monochrome numbers. Despite their font-like precision, each date has been meticulously hand-lettered with several coats of paint. If the canvas couldn't be finished on the given day, Kawara would have it destroyed. The repetitive labor involved in the creation of these paintings is indivisible from their concept, however we choose to interpret it.

Christian Marclay's *The Clock* is a looped 24-hour-long video montage of clocks from the archives of cinema and television, assembled over the course of three years. Certain shared traits emerge for each time of day, uniting the footage into a hypnotic collage. The lengthy nature of the piece itself becomes an active part of the project, as the viewers' attention spans and bodily demands loom in increasing prominence against the installation.

JUST AS EACH of Monet's paintings of the Rouen Cathedral is a different Rouen Cathedral, the street we pass on our daily walk is a different street each day, and every moment of each day. Even if we were to dedicate, through some generous allowance, the remainder of our lives to observing one such street, it would still escape our scrutiny, rewriting itself in perpetuity at every blink of the eye.

# 3.
# SHHH!

TO HEAR SILENCE IS to see the staves on which the notes are hung in order or disorder.

As with other forms of doing nothing, shushing ourselves is borderline impossible, which doesn't mean it isn't worth a try: attempting to silence our thoughts can bring out subtler movements, concealed in daily rhythms. Giving them an echo chamber allows us to us hear ourselves, as well as the noise that frames our search for silence.

Near the end of James Joyce's *A Portrait of the Artist as a Young Man*, Stephen Dedalus, the titular young man, proclaims his artistic intentions: "to try to express myself in some mode of life or art as freely as I can and as wholly as I can, using for my defense the only arms I allow myself to use—silence, exile and cunning." Several pages later, the novel ends, and Stephen leaves for Paris. We meet him again in the beginning of *Ulysses*, back in Dublin. He is poor and unhappy, and burdened by Buck Mulligan, one of the more obnoxious roommates in the history of literature. To go by the checklist, Stephen has exile covered (for a bit), we can't deny him cunning (at least in terms of rhetoric), and as for

silence, he manages it pretty well until Episode Three, where we get a short glimpse into the workings of his mind. At this dense and convoluted intersection of memories, references, and impressions, most first-time readers of *Ulysses* tend to give up. The chapter is daunting and confusing, but so is life.

"Stream of consciousness," the term often used to describe Joyce's narrative technique, is a misleading one—it suggests a linear flow, as rigid as the lines of text that bear the weight of literary modernism. Instead, it's an assemblage of centrifugal trails, approximating the movements of our mind, in format and in style. László Krasznahorkai's sentences can run for pages on end, occasionally stopping only at the end of the chapter, or at the end of the entire book. Such writing may feel abstruse, but in a way, it's closer to reality than naturalistic prose. Our thoughts tend to follow each other with little regard for sense and punctuation, until we edit them into a palatable shape.

Off the page, consciousness does not unfurl into a stream at all; it circles in a boundless body of water, composed of intermingling streams. And while our visual and linguistic faculties translate these thoughts one at a time, the others wait their turn and, in the meantime, flow between the foreground and the background. If we somehow managed to transcribe our thoughts, unedited and pure, the resulting chaos would confuse us no less than *Ulysses*, or all the experimental literature that followed in its wake.

In *Madness, Rack, and Honey*, Mary Ruefle writes that "the wasting of time is the most personal, most private, most

intimate form of conversation with oneself, as well as another." Perhaps a better term to describe stream of consciousness is "interior monologue." That wording is more apt, although it may as well be "interior dialogue," or "interior symposium," or "interior cacophony." For the sake of daily survival, and to avoid successive existential crises, we transcribe this cacophony into a string of words in varying degrees of coherence. It would be a bit much to contemplate at length each traffic light we come across, but every now and then our inner editor can take a break and let us revel in the maddening complexity.

PAYING ATTENTION TO SILENCE can enrich the music that follows it.

In their essay "How to Read *Nancy*," Mark Newgarden and Paul Karasik liken Ernie Bushmiller's comic strip to a stop sign—it takes more effort to not read it than to read it. The eye jumps from panel to panel, only noticing the nature of the medium when it doesn't work. The empty white space between two panels contains the mental distance required for the transition to take place. This transition relies more on internal logic and style, rather than on some universal guideline—for example, the backgrounds of *Krazy Kat* change even when the characters are standing in the same spot. Despite the strangeness of this detail, the ever-morphing scenery is so consistent with the surreal language of the strip that many readers don't notice it at all. Within the gutters of a comic strip is a silence that can last a fraction of a second, or a lifetime and a half.

What happens between the cuts of a movie? In a smooth edit, we barely register the camera shifts, as the shots merge into a seamless flow. But things don't have to be so clean: in "You Must Remember This," Robert Coover takes a

suggestive fade-out from *Casablanca* and blows it up into a delirious erotic comedy. The story imagines what happens behind the reel, turning the silence inside out and shredding it into pieces.

Andrei Tarkovsky's *Stalker* abounds in drawn-out silences that bring forward each minute noise and change in composition. One of the film's most memorable scenes is the long tracking shot of a railway draisine carrying three disgruntled Russian men, all actively avoiding eye contact and saying nothing throughout the entire ride. These minutes can feel prolonged and uncomfortable, but if we consider how much time we spend silently bobbling on buses and leaning in elevators, there's nothing shocking in the scene. When something so quiet is given so much room, the emptiness is made concrete and powerfully affecting, forcing the viewers to reconsider each element, as well as their preconceptions of the cinematic medium itself.

With any medium, both the consumers and the creators are quick to develop a framework of expectation that leaves no room for silence. By opening gaps in these models and expanding the silences they hold, any given structure can be dismantled and rearranged.

Faced with unexpected emptiness, the audience is invited to engage more closely with the piece, or leave, or both. John Cage's *4′33″* is a three-movement composition in which the musicians are instructed to do nothing for the duration of four minutes and thirty-three seconds. As Cage himself explained it, "There's no such thing as silence. What they thought was silence, because they didn't know how to listen, was full of accidental sounds. You could hear the wind stirring outside during the first movement. During the second, raindrops began pattering the roof, and during the third the people themselves made all kinds of interesting sounds as they talked or walked out." The last phrase is telling: the sound of the audience's rejection can be a part of the piece.

WRITING OR DRAWING is making marks on a surface.

Unfamiliar alphabets can have a purely visual appeal; as we lack the grammar to decipher the letters, we have the advantage of seeing them stripped of their linguistic weight. Resisting the impulse to dispel this confusion can make us more aware of the way we react to the unknown, and help us understand the intricacies of our own verbal patterns.

Even within one culture, written language can fall into obscurity. In Chinese calligraphy, the "wild cursive" style of *caoshu* is an unrestrained explosion of lines that can be deciphered only by practitioners and experts. Its illegibility doesn't detract from the beauty of the brushwork, even if the meaning of the characters is entirely beyond the viewer's comprehension. To see our own writing or drawing as both lines and cyphers is to divorce ourselves from mental short-cuts—useful in getting from bed to bath, but limiting when it comes to the beyond.

Saul Steinberg once described himself as "a writer who draws," and indeed, many of his cartoons can be seen as illustrated contemplations rather than jokes (fortunately, that does not detract from their humor). One of them shows a dejected employee faced with a speech balloon shaped like a giant "NO," filled to the brim with florid gibberish. Steinberg reused this elaborately meaningless script in the fake certificates he issued for his friends, setting the assumed gravity of official documents against the fragile nature of their medium.

There's a reason why many authors still choose to write longhand—typing a word doesn't quite carry the same tactile sensation as scratching it onto paper with a pencil or a pen. The physical act of writing allows us to feel the lightness or the weight of words, their gestures and voices. Within the silent act of writing is a density of sound—the way we outline the letters, the scrape of graphite or metal on paper. These subtleties have an impact on our style, even when we don't consciously register them; writing by hand allows for greater variation than typing on a keyboard, unless of course the keys are struck with enough vehemence to impart the significance of battered words to the rest of the café.

Writing longhand also forces us to slow down and consider each word with greater care. What's more, a handwritten manuscript carries traces of the work that went into a sentence. Sometimes a discarded phrase from the first, third, or thirtieth draft is better than its final iteration. Our manuscripts reveal the way our minds work: how many lines cross out a line of text, how hard the pen cuts into paper, how linear or convoluted are the arrows, notes, and substitutions. Reappraising our drafts and works in progress for their form alone can give us a fresh view of our personality, and our creative process.

BY OBSERVING OURSELVES, we write, edit, and rewrite a character study, or rather, given the complexity of the job, a series of character studies.

Through budgetary and temporal restraints, all of these characters are acted out by one increasingly disheveled actor, with a receding list of aspirations and no retirement plan in sight.

Instead of being ourselves, we can embrace this multiplicity. The rapper Kool Keith has more than fifty eccentric alter egos in his oeuvre, from the East Coast big shot Poppa Large to the extraterrestrial time-traveling gynecologist Dr. Octagon. Each one has a different lexicon and style, but all of them are united in an aesthetic vision. These characters allow the artist to spread his output in multiple directions, instead of being locked within a single stage persona.

No matter how much we invest in the pursuit of authenticity, being oneself is an act. As Mary Ruefle puts it in her

lecture "On Beginnings," "self-consciousness is its own pretension. . . . theater requires that you draw a circle around the action and observe it from outside the circle; in other words, self-consciousness is theater."

In his show *'90s Comedian*, Stewart Lee draws such a circle directly on the stage, with chalk. Borrowing from the practices of Corbières and Pueblo clowns, he uses the circle in the most challenging section of the monologue to delineate his position as the character of Stewart Lee, rather than the actual Stewart Lee, who happens to share his name and appearance. This onstage character clings to failure and rejection, admonishing the audience for not recognizing his genius. After decades of work, however, Lee managed to amass a dedicated following, which meant that his character no longer had much to be sour about. At this point, he introduced a degree of self-sabotage into his shows to lower his status to the familiar level. Lee deliberately made jokes that wouldn't work and then examined them in obsessive detail, picking on any small distractions in the routine, and even staging a nervous breakdown.

It can be terrifying to abandon what we do well and do the opposite, but that can be the only way to break the mold. Artistic self-sabotage brings additional challenges to the already difficult vocation, forcing artists to reinvent themselves, regardless of their audience's expectations.

Hergé's boy reporter Tintin is seen writing only once, in the first volume, *Tintin in the Land of the Soviets*. He locks himself in a room, writes too much, postpones mailing the report,

and never attempts to write anything again, at least not in the comics. Of course, we can imagine him filing reports between the volumes. Perhaps he is the author of these books, which would explain his phenomenal proficiency in operating vehicles that require prior training. As a full-time adventurer, Tintin's behavior would be better justified, but as a reporter, his adventures are all the more extraordinary.

Examining our character requires time and space, and a degree of silence. Regular meditation can give our lives a sense of balance and rhythm, but more pertinently to the doing of nothing, meditation can be an exercise in facing our selves. At first, even a few minutes of silence can seem like an eternity, but with patience and commitment, daily meditation can become as natural as sleep. Although there

are numerous ways of approaching this practice, it can be as simple as closing one's eyes and sitting still for twenty minutes while thoughts and sensations assemble themselves out of the usual mess into a compact inventory.

THE SILENCE of lived minutes and the effects of time are as much a part of any artwork as its physical material.

Early in the 1990s, Chinese calligraphers took their practice to the streets. They'd write poems and aphorisms with water and brush, for any passerby to see, if only for a minute. This art is no different from leaving marks with ink or paint, except that the ephemeral nature of these marks is more apparent.

"Go to the beach and make graphic signs in the sand," Joan Miró wrote, "draw by pissing on the dry ground, design in space by recording the songs of the birds, the sounds of water and wind . . . and the chant of insects." By giving voice to the activities we carry out in silence, we elevate our entire vocal range.

In 1975, David Ireland bought a Victorian house in the Mission District of San Francisco. Together with the previous owner, accordion maker P. Greub, he attempted to move one of Greub's heavy safes downstairs—the safe slid out of their hands and dented the walls of Ireland's new home. Instead of fixing the dents, he commemorated them with museum plaques: "THE SAFE GETS AWAY FOR THE FIRST TIME, NOVEMBER 5, 1975" and "THE SAFE GETS AWAY FOR THE SECOND TIME, NOVEMBER 5, 1975."

Ireland proceeded to strip down the interior, uncovering layers of the building's history, from an elaborate signature left by the wallpaper artists to a network of pulleys and wires behind the windows. He applied multiple layers of varnish to the bared walls, inviting light from the street as a collaborator. Over the years, the house became a perpetual self-portrait of the artist, and with each uncovered layer, Ireland left a layer of his own—the products of leisure and work, and all the time spent doing nothing.

We can see art as a by-product of living, or we can treat our lives as works of art. How we define these margins is how we choose to spend our days, in steady rhythms, languid progressions, or improvised discord.

# 4.

# COWS AND THINGS OTHER THAN COWS

LET'S TAKE A COW out of its barn and see how far it strays, impelled by force of idle speculation.

Towards the end of *A Portrait of the Artist as a Young Man*, Stephen Dedalus asks a hypothetical question: "If a man hacking in fury at a block of wood, make there an image of a cow, is that image a work of art? If not, why not?" In 2014, Ted Cruz tweeted a photo of a cow made out of butter with a not dissimilar sense of wonder: "Wow, a cow made of butter. My girls would love it. In fact, the first sentence Caroline ever said was 'I like butter.'"

Neither a cow made out of wood nor a cow made out of butter needs to exist. They fulfill little function other than keeping the flow of Joycean scholarship constant and inspiring accidental poetry in American politicians.

Sometimes, objects and words with no aspiration to art can display qualities that wouldn't be out of place in a museum or a novel. These qualities are not exclusively contained within chance arrangements; they rely on a subjective vision to give them value and form. Some of us can only appreciate art if it's framed and hung in a gallery; others

prefer it in the wild; a patient observer would make no such distinction, no matter where they are.

A slight change of format turns the buttery tweet into a poem (of sorts):

Wow, a cow
Made of butter.
My girls would love it.
In fact, the first sentence
Caroline ever said
Was 'I like butter.'

Meanwhile, if Joyce's furious lumberjack had never seen a cow in his life, and ended up with a cow carved out of wood, he'd give it no second thought and toss it in the furnace along with the rest of the lumber. If said lumberjack were more curious, he might examine the cow regardless of its familiarity, give it a background story and a name.

Likewise, a different politician might see a cow made of butter and mercilessly gouge out its eyes to butter a bit of toast that he'd conveniently stashed in his breast pocket. Yet another politician might wonder if a real cow could feel residual pride, tinged with confusion and ennui at the sight of a cow made out of butter. A fourth politician might wonder if it makes a difference whether the butter was churned from the cow that modeled for the statue, and how that cow would treat its doppelgänger. A fifth politician might wonder if the cow is not unlike Damien Hirst's controversial piece *The Physical Impossibility of Death in the Mind of Someone Living*, commonly referred to as "a shark in formaldehyde." A sixth politician might even imagine the cow made of butter in Tate or MOMA and compose an explicatory plaque, giving it sufficient grounds to leave the county fair. All that it takes is a little shift in scale.

In the sitcom *Father Ted*, the eponymous protagonist explains to his younger colleague, Father Dougal, the difference between the cows in the distance and the miniature cows in his hand: "These are small, while those are far away." Dougal doesn't get it, and Ted abandons the whole thing in exasperation. Despite Dougal's idiocy, or maybe because of it, his perspective offers a revealing look at the familiar by approaching it from an unorthodox angle.

The old-fashioned sitcom set is a deeply unnatural construct that requires significant suspension of disbelief to function, not unlike a two-dimensional perspective drawing. If the cows of *Father Ted* take a stroll into a drawn scene,

Dougal's refusal to accept the concept of distance stops being comical and becomes a subversion of visual norms. The line between genius and imbecility can be thin and wobbly.

Innately, we sense the difference between a drawing that deliberately bends or ignores the rules of perspective and a drawing that seems unintentionally surreal through artistic shortcomings. Instead of judging the merit of either drawing, it's worth exploring the network of assumptions that inform our first opinions. Alternatively, we can suspend our questions, and milk the subject for all it's worth.

After moving to the countryside, Lydia Davis began watching a group of cows across the street from her house. Over time, she wrote short meditations on their movements, attitudes, and expressions, without imposing on her subjects any overt interpretation, instead allowing them to graze in placid, meadowy prose. In an interview with *The Paris Review*, Davis said: "If something interests me, whether it's a piece of language or a family relationship or a cow, then I write about it. I never judge ahead of time. I never ask, Is this worth writing about?" The most mundane and overlooked aspects of life can inspire great art, while the most extraordinary events fall flat without a thoughtful treatment.

In an interview with *The White Review*, Deborah Levy related the birth of her novel *Hot Milk*: ". . . So I thought, 'What if I started a book, in a chain store coffee house, with the milk being frothed?' And I ended up in a field with a calf suckling a cow, and that's just how it goes for me." The coffee shop is barely present in the novel, while at the center of

the story is the relationship between a human mother and her equally human daughter. The original idea can stray so far as to become virtually invisible. What dissolves in the artistic process is present in the final piece, if only as a phantom memory.

The frightening volume of identical tourist photos shows that the greatest wonders of humankind can turn to anonymous points of reference, while a humble cow (made out of wood, or butter, or cow), approached with patience and curiosity, can be an endless source of inspiration.

**5.**

# HOW
# TO DO
# NOTHING
# (WELL)

THE READER MAY ASK, Did you work hard on this book about doing nothing? Obviously you did, because the book is excellent (thank you), but isn't that a bit of a contradiction?

Well, no, dear reader, doing nothing is not at all in conflict with hard work—on the contrary, it can reinforce good working habits. Most of this book was written on scraps of paper, on napkins, and occasionally on parts of the author's anatomy. As the notes were deciphered, rewritten, and rewritten again (and again), they arranged themselves by theme into a fitting order. Although it took a while, the author never troubled himself with all-nighters or excess caffeine. Being naturally lazy, he rarely wrote or drew for more than a couple of consecutive hours, but he worked on the book every other morning, before attending to the day's work. Approaching a large project in small doses allows plenty of time for structural and conceptual links to pop up on their own, instead of being forced out of the brain with rusty garden pliers.

A number of the author's colleagues find this routine torturously stretched, and prefer to work in binges and switch

off afterward. The colleagues in question seem to function fairly well—alternating long breaks with long periods of work is just a different ratio of action and inaction.

Some of us crave order; others thrive in chaos. Some need both, in varying proportion, in unison or in succession. Time for doing nothing may come in sudden bursts, interspersed with work and leisure, or stay confined to certain hours, according to schedule and mood.

It pays to attune ourselves to our temperaments and their fluctuations: to daydream when the brain is buzzing with ideas is just as hard as to be creative when the brain is half asleep. Many artists prefer to do their creative work first thing in the morning, when the mist of dreams is not entirely dissolved. In the middle of the day, we tend to be more sober and less adventurous, so it can be a good time to assess our progress critically. Afternoons are often left for editing, coloring, and other activities that don't require complete presence of mind. Evenings are well-suited for reading and studying, while bedtime can be a reprise of the morning for the night-owlish among us.

This schedule is merely a sample, gleaned from the habits of various artists who cared to transcribe their routines. Some like to wake up early and do most of their creative work before their day jobs; others attend to their art at intervals and after hours. These schedules may change from year to year, from day to day, or even within a single day. While there's no universal formula, we can study the lives of the artists we admire and try on their methods.

Most of us don't have the luxury of doing what our hearts desire at any given time. Therefore, it's all the more important to listen to the mind's demands, so they can be noted and attended to when time and place allow.

Under the weight of daily life, the pursuit of art and leisure can seem suspended in a nebulous promise of eventual free time. These pursuits shouldn't be relegated to art residencies and retirement homes. All ideas and observations, no matter how small or ambitious, should be noted and considered, at lunch breaks, on bus rides, or in the smaller hours. It's worth taking stock of the available time

and treating it with greater care. Even half an hour of uninterrupted reading can make a difference—doing nothing is a cumulative effort that gets easier with practice, and eventually becomes second nature.

When free time is in short supply, doing nothing can be exercised in miniature, concurrently with daily chores. Cooking, tidying, folding laundry, and washing dishes are good opportunities for reflection within the comforts of a familiar structure. If nothing else, these chores offer a welcome respite from mental activity, as well as a clean room and a homemade dinner.

One of the less daunting OuLiPian constraints is the "Subway Poem": come up with a line of verse while the train is moving, write it down at the stop, repeat until the destination is reached (both literally and compositionally). And if no lines come to mind, a subway ride is another chance to study the quotidian—the way people read, talk, move, or stand still, doing nothing in an infinity of ways.

## "WHERE DO YOU GET YOUR IDEAS?"

Of all the things an author can be asked, this one is most likely to elicit a throbbing sigh. And yet, the question continues to be asked, and rarely answered. Why? Because the origins of good ideas are too complex to be contained in blurby summaries.

Edgar Degas once complained to Stéphane Mallarmé of having too many ideas for poetry, to which Mallarmé replied that poems aren't made with ideas—they're made with words. Even if it is possible to start with an idea, it can be more rewarding to let the concept reveal itself in the creative process.

Mallarmé occupied his later years with the idea of The Book, made up of everything and all the relations between the things within that everything. Appropriately, this ambitious project doesn't exist in the form of an actual book. Rather, The Book can be regarded as the universal source text that, once found, will reveal the lineage, ingredients, and roots of every work of art ever conceived or executed. We know we'll never find that source, and yet we can't ignore its

ghostly presence. Meanwhile, ideas circle the periphery of our vision, eventually closing in to manifest themselves with a loose sense of timing and propriety.

It's no coincidence that inspiration often seems to confront us out of nowhere: on a stroll, or in the middle of a shower (unless the hygienic act is approached with a degree of scrutiny that leaves no room for other thoughts). These ideas don't come out of nowhere. They are products of our cultural and experiential baggage, our memories and dreams, mixed up and stirred and thoroughly condensed.

Active thought is only one part of the artistic process, and for many artists it's a proportionally small part. The rest happens during downtime, when the mind appears to be at rest, weaving invisible connections.

The creative act is often so mysterious as to make the artist appear secondary, as if employed by some outside force in the capacity of an assistant. Authors occasionally describe their work as writing under dictation, which may lead us to believe that some unfathomable talent is at work. It is more likely that the sum of the artist's experience has grown beyond their grasp, and its workings have become inexplicable. Hands and other relevant extremities move on their own, and the ideas that provoke these movements only reveal themselves years or decades later.

Miguel de Cervantes started writing *Don Quixote* to ridicule a genre of romantic literature that, centuries after his death, is remembered chiefly in connection with the book. Over time, the character of Quixote acquired conceptual

depth and, in his adjectival form, outlived the author and his intentions.

We have as much control over artistic output as we have over bowel movements. Our work depends a great deal more on the quality and quantity of art consumed and life examined than on the manner of their eventual excretion. To wrap up this sordid metaphor, a certain amount of emptiness is good for digestion, otherwise our intake and output leaves no room for healthy contemplation.

ARTISTIC WELL-BEING is a balancing act between limited abilities and infinite demand.

Setting impossible standards and admonishing ourselves for falling short of them can lead to pure misery. On the other hand, setting low standards allows for minimal challenge and growth. It takes courage to pick an impossible goal, fully aware that we will never make it, and to appreciate the result soberly, succumbing neither to self-loathing nor self-pity.

To ease the tension is to remove the flavor of the work. In reasonable amounts and consciously applied, tension can be good for art. A certain disappointment with the medium we're working in can help steer our work away from trends and clichés. After all, if the existing art satisfied all our demands, why bother making more?

An adequate assessment requires distance and time. It's borderline impossible to see things clearly while we are frustrated with the results. With time, frustration clears, and the

shape of the work emerges into focus. Unpleasant as it is, creative misery is a sign of passion, which can, through analysis and application, grow into something constructive. At the very least, it's better than indifference.

WITHOUT SELF-CRITICISM, good ideas may never reach their full expression.

Our inner critics should be given plenty of time to reappraise our work, however long it takes for a fresh perspective to develop.

According to Flannery O'Connor, "the writer has to judge himself with a stranger's eye and a stranger's severity." As painful as this severity can feel, it tends to signal dissatisfaction that often hides behind the process. When the inner critic tells us to burn our dreams and apologize to the universe for trying, we can attempt to pinpoint what it is that we dislike in our current work, and decide whether it's time for a different approach or a subtle work-around. When we reappraise our long-abandoned work, its most repellent elements can suddenly appear not all that awful after all, at times even inspiring. To a versatile artist, a shortcoming can be a hint toward a new style, rather than a dead end.

THEN THERE IS the outer critic, or simply put, the critic. If the criticism is constructive, we may consider ourselves lucky. If the criticism is not constructive, the best thing to do is nothing. That may be hard—humans are awfully sensitive creatures, even the ones who act indifferent and wear

sunglasses indoors. Fortunately, time and repetition turn the most vicious attacks into minor anecdotes. As with heartbreaks, each subsequent negative review is less of a shock, until eventually we can pick out the valid points and disregard the rest.

Awards and competitions are fickle things that reflect more on prevailing trends and opinions than on the value of the artwork. If the artist is willing to keep up their practice in the full conviction that it will never be appreciated, the work is worth doing.

That said, awards and competitions don't have to be avoided—they can advance a career or provide an opportunity for an amusing speech. Things become problematic when the pursuit of acclaim influences artistic decisions.

IDLENESS DOESN'T have to be idle. It can be passive or active, or both at once.

Rearranging books, for instance, can be an active artistic exercise. To escape the trappings of genre definition, Mary Ruefle proposes arranging books by the color of their spines. A lonely Pantone swatch is one color, but the same swatch set next to a different one is a brand-new color. The negative space between the swatches can be part of the palette, and the combination of two colors can create a third one, as in the illustrations that accompany this text. Likewise, books aren't isolated containers of information; they talk and argue

with each other, and change their tone and pitch according to the order in which they are examined.

Georges Perec's love of the ordinary found its clearest expression in *An Attempt at Exhausting a Place in Paris*. The book is a collection of short observations, written in the cafés of Place Saint-Sulpice. For this project, Perec chose to focus on the details that tend to be ignored: incidental gestures and signs, the procession of buses, the movements of pigeons and crowds. Something as passive as staring out the window can give us more material than we can ever use. Every minute, a veritable parade of stories passes by, and their complexity and genre depends entirely on our vision.

W. Reginald Bray did not attach any artistic worth to his eccentricities, although they can be seen as performance art of the livelier kind. In 1898 he purchased a copy of the *Post Office Guide*, and decided to test the limits and patience of the British postal system by mailing a succession of increasingly unwieldy objects, including a turnip, a bicycle pump, a lump of seaweed, his dog, and, eventually, himself. Bray had no aspirations for artistic fame and did all this entirely for fun, which doesn't make his peculiar hobby less artistic or noble. It involved in equal doses action and inaction, and could only be conceived by a playful idle mind.

Life is absurd and complicated. Sometimes, the only way to make sense of it is to complicate it even further and to celebrate the mess that comes out as a result. A roundabout way of arranging our possessions may not be sensible, but it may give the day-to-day a bit of extra color.

INSTEAD OF a cozy conclusion to this book, why not consider our own conclusion, that is to say, the deathbed (assuming that we'll have beds intended for our expiry, and instead of going out with a quick snap, our candles will fade at a pace that allows for end-of-life accounting). Morbid details aside, such speculations can remind us of the things that make life precious. Regardless of our proximity to the end, it's hard to imagine ourselves fondly reminiscing about grades, trophies, and promotions.

More memorable are the rare moments of clarity that leave us with a glimpse of something larger than ourselves. Whether or not these moments lead to works of art does not affect their value. The wasted time is worth it, if only for the memories.

Our modest lives are threaded through with boundless potential. We'll never see more than a fraction of its worth, but we can follow one of the threads until it splits and branches out into the horizon, and infinitely out of grasp. And when the day's work is done, we can assemble our ideas and find them good or bad, or somewhere in-between, or even nonexistent. In the latter case, we may be moved to note that today we did nothing.

Doesn't matter.

# BIBLIOGRAPHY

Aguilar, Andrea and Johanne Fronth-Nygren. "Lydia Davis, Art of Fiction No. 227." *The Paris Review* 212, Spring 2015.

Aira, César. *The Literary Conference*. New York: New Directions, 2010.

———. *Varamo*. New York: New Directions, 2012.

Bachelard, Gaston. *The Poetics of Space*. Translated by Maria Jolas. New York: Penguin, 2014.

Bair, Deirdre. *Saul Steinberg: A Biography*. New York: Random House, 2012.

Barry, Lynda. *What It Is*. Montreal, QC: Drawn and Quarterly, 2008.

Baudelaire, Charles. *The Painter of Modern Life and Other Essays*. Translated by Jonathan Mayne. London: Phaidon Press, 1964.

Beckett, Samuel. *The Letters of Samuel Beckett*. Cambridge: Cambridge University Press, 2011.

Benjamin, Walter. *Illuminations: Essays and Reflections*. Translated by Harry Zohn. New York: Schocken, 1969.

———. *One-Way Street*. Translated by Edmund Jephcott. Cambridge, MA: Harvard University Press, 2016.

———. *Reflections: Essays, Aphorisms, Autobiographical Writings*. Translated by Edmund Jephcott. New York: Schocken, 1986.

Blistein, Jon. "Watch Iggy Pop Talk Stooges' Ethos in 'Gimme Danger' Trailer." *Rolling Stone*, September 2016. https://www.rollingstone.com/movies/news/watch-iggy-pop-talk-stooges-ethos-in-gimme-danger-trailer-w442720

Bolaño, Roberto. *2666*. Translated by Natasha Wimmer. London: Macmillan, 2009.

———. *The Insufferable Gaucho*. Translated by Chris Andrews. New York: New Directions, 2013.

Borges, Jorge Luis. *Collected Fictions*. Translated by Andrew Hurley. New York: Penguin Books, 1999.

Brunetti, Ivan. *Aesthetics: A Memoir*. New Haven, CT: Yale University Press, 2013.

———. *Cartooning: Philosophy and Practice*. New Haven, CT: Yale University Press, 2011.

Calle, Sophie and Kimberly Chou. "Sophie Calle: Remembrance of Gardner Paintings Lost." *ARTnews*, November 2013.

Calvino, Italo. *Invisible Cities*. Translated by William Weaver. Boston: Houghton Mifflin Harcourt, 1978.

———. *Six Memos for the Next Millennium*. Translated by Geoffrey Brock. Boston: Houghton Mifflin Harcourt, 2016.

Carroll, Lewis. *Sylvie and Bruno Concluded*. London: Macmillan, 1893.

———. *The Hunting of the Snark*. London: Tate Publishing, 2011.

Carson, Anne. *Float*. New York: Knopf, 2016.

Cervantes, Miguel. *Don Quixote*. Translated by John Rutherford. London: Penguin Classics, 2003.

Coover, Robert. *A Night at the Movies Or, You Must Remember This*. McLean, IL: Dalkey Archive Press, 1992.

Cruz, Ted. Twitter, 2014. https://twitter.com/tedcruz/status /498211667818586112

Davis, Lydia. *Can't and Won't*. New York: Picador, 2015.

Debord, Guy. *The Society of the Spectacle*. Translated by Ken Knabb. London: Black & Red, 2000.

Dickens, Charles. *The Uncommercial Traveller*. Oxford: Oxford University Press, 2015.

Doran, John. "Messing Up the Paintwork: This Nation's Saving Grace Revisited." *The Quietus*, January 2011. http://thequietus.com/articles/05559-this-nations-saving-grace-the-fall

Eliot, T. S. *Selected Essays*. London: Faber & Faber, 1999.

Elkin, Lauren. *Flâneuse: Women Walk the City in Paris, New York, Tokyo, Venice, and London*. London: Chatto & Windus, 2016.

Ellmann, Richard. *James Joyce*. Oxford: Oxford University Press, 1959.

*Fact Magazine*. "Matmos' new album Ultimate Care II is sampled entirely from a washing machine." *Fact Magazine*, Nov. 6, 2015. http://www.factmag.com/2015/11/06/matmos-ultimate-care-ii-sampled-entirely-from-a-washing-machine/

*Father Ted: Hell*. Directed by Declan Lowney, written by Graham Linehand and Arthur Mathews. London: Hat Trick Productions, 1996.

Galchen, Rivka. "The Profound Empathy of Yoko Tawada." *The New York Times Magazine*, Oct. 27, 2016.

Gann, Kyle. *No Such Thing as Silence: John Cage's 4′33″*. New Haven: Yale University Press, 2011.

Garréta, Anne. *Sphinx*. Translated by Emma Ramadan. Dallas: Deep Vellum Publishing, 2015.

Goblet, Dominique and Nikita Fossoul. *Chronographie*. Paris: L'Association, 2010.

Green, Dennis. "How a $12 Million Monet Painting Was Fully Restored After a Man Punched It." *Business Insider,* Jan. 26, 2015. http://www.businessinsider.com/monet-painting-restored-after-punching-2015-1

Gruen, John. "Agnes Martin: 'Everything, everything is about feeling . . . feeling and recognition.'" *ARTnews*, September 1976.

Hensley, Tim. *NSFW*. Blog Flume, May 8, 2015. https://blogflumer.blogspot.com.es/2010/05/nsfw.html

Hergé. *Tintin in the Land of the Soviets*. Translated by Leslie Lonsdale-Cooper and Michael Turner. New York: Little, Brown Books, 2007.

Herriman, George. *Krazy & Ignatz*. Seattle: Fantagraphics, 2011.

Horowitz, Steven J. "Sir Mix-A-Lot on Nicki Minaj's 'Anaconda,' Booty Fever & New Music." *Billboard*, Sept. 12, 2014. http://www.billboard.com/articles/columns/the-juice/6251411/sir-mix-a-lot-on-nicki-minajs-anaconda-booty-fever-new-music

Hsieh, Tehching and Adrian Heathfield. *Out of Now: The Lifeworks of Tehching Hsieh*. Cambridge, MA.: The MIT Press, 2015.

Jansson, Tove. *Moomin: The Complete Tove Jansson Comic Strip*. Montreal: Drawn & Quarterly, 2006.

Joyce, James. *A Portrait of the Artist as a Young Man*. New York: Penguin Classics, 2003.

———. *Finnegans Wake*. London: Penguin Classics, 1999.

———. *Ulysses*. New York: Vintage, 1990.

Kafka, Franz. *Aphorisms*. Translated by Willa and Edwin Muir and Michael Hofmann. New York: Schocken, 2015.

———. *Diaries, 1910–1923*. Translated by Joseph Kresh and Martin Greenberg with Hannah Arendt. New York: Schocken, 1988.

———. *Metamorphosis and Other Stories*. Translated by Michael Hofmann. New York: Penguin Classics, 2008.

Kharms, Daniil. *Complete Works*. Moscow: Azbuka, 2015.

Lee, Douglas. *Masterworks of 20th-Century Music: The Modern Repertory of the Symphony Orchestra*. New York: Routledge, 2002.

Lee, Stewart. *How I Escaped My Certain Fate: The Life and Deaths of a Stand-Up Comedian*. London: Faber & Faber, 2011.

Lewallen, Constance. *500 Capp Street: David Ireland's House*. Oakland: University of California Press, 2015.

Lispector, Clarice. *The Complete Stories*. Translated by Katrina Dodson. New York: New Directions, 2015.

Markson, David. *Wittgenstein's Mistress*. McLean, IL.: Dalkey Archive Press, 2006.

McNaught, Jon. *Dockwood*. London: Nobrow Press, 2012.

Mercier, Vivian. "The Uneventful Event." *The Irish Times*, Feb. 18, 1956.

Montalbetti, Christine. *Western*. McLean, IL.: Dalkey Archive Press, 2009.

Doherty, Mark, and Murphy, Barry, writers and editors. *Soupy Norman*. Eight-part miniseries, aired May 24, 2007, to July 12, 2007, on RTÉ Two. http://www.rte.ie/tv/soupynorman/

Nabokov, Vladimir. *Lectures on Literature*. Boston: Houghton Mifflin Harcourt, 2002.

———. *Speak, Memory: An Autobiography Revisited*. New York: Knopf, 1989.

Newgarden, Mark and Paul Karasik. "How to Read *Nancy*: The Best of Ernie Bushmiller's *Nancy*." 1988. http://www.laffpix.com /howtoreadnancy.pdf

O'Brien, Flann. *At Swim-Two-Birds*. McLean, IL.: Dalkey Archive Press, 2005.

O'Connor, Flannery. *Mystery and Manners: Occasional Prose*. London: Macmillan, 1970.

Oltermann, Phillip. "Jenny Erpenbeck: 'People in the West Were Much More Easily Manipulated.'" *The Guardian*, June 6, 2015. https:// www.theguardian.com/books/2015/jun/06/jenny-erpenbeck -interview-time

Perec, Georges. *A Void*. Translated by Gilbert Adair. Boston: David R. Godine, 2005.

———. *An Attempt at Exhausting a Place in Paris*. Translated by Marc Lowenthal. Adelaide, Australia: Wakefield Press, 2010.

———. *Life a User's Manual*. Translated by David Bellos. Boston: David R. Godine, 2009.

———. *Species of Spaces and Other Pieces*. Translated by John Sturrock. London: Penguin, 1997.

Phaidon. "The Guggenheim's Jeffrey Weiss talks On Kawara." Phaidon, February 2015. http://es.phaidon.com/agenda/art/articles/2015 /february/06/the-guggenheims-jeffrey-weiss-talks-on-kawara/

Proust, Marcel. *In Search of Lost Time*. Translated by C. K. Scott Moncrieff, Terence Kilmartin, and Andreas Mayor. New York: Modern Library, 2013.

Queneau, Raymond. *Exercises in Style*. Translated by Barbara Wright. New York: New Directions, 2013.

Roussel, Raymond. *Locus Solus*. Translated by Rupert Copeland Cunningham. Richmond, UK: Alma Books, 2012.

---

Ruefle, Mary. *Madness, Rack, and Honey*. Seattle: Wave Books, 2012.

Sante, Luc. *The Other Paris*. New York: Farrar, Straus and Giroux, 2015.

Saroyan, Aram. *Complete Minimal Poems*. Brooklyn, NY: Ugly Duckling Presse, 2007.

Schrauwen, Olivier. *Arsene Schrauwen*. Seattle: Fantagraphics, 2014.

Scholle, Ellen M. "Oral history interview with Edward M. M. Warburg." Archives of American Art Oral History, May 13, 1971.

Sebald, W. G. *The Rings of Saturn*. Translated by Michael Hulse. New York: New Directions, 1999.

Solnit, Rebecca. *A Field Guide to Getting Lost*. New York: Penguin Books, 2006.

Sōseki, Natsume. *I Am a Cat*. Translated by Aiko Ito and Graeme Wilson. Rutland, VT: Tuttle Classics, 2006.

Sterne, Laurence. *The Life and Opinions of Tristram Shandy, Gentleman*. London: Visual Editions, 2011.

Testard, Jacques. "Interview with Deborah Levy." *The White Review* 8, August 2013.

Tingey, John. *The Englishman Who Posted Himself and Other Curious Objects*. Princeton, NJ: Princeton Architectural Press, 2010.

Tomkins, Calvin. *Duchamp: A Biography*. New York: The Museum of Modern Art, 2013.

Toussaint, Jean-Philippe. *Urgency and Patience*. Translated by Edward Gauvin. McLean, IL: Dalkey Archive Press, 2015.

Turchi, Peter. *Maps of the Imagination*. San Antonio, TX: Trinity University Press, 2007.

Turner, Elizabeth Hutton and Oliver Wick. *Calder, Miró*. London: Philip Wilson, 2004.

Valéry, Paul. *Degas, Manet, Morisot*. Translated by David Paul. Princeton, NJ: Princeton University Press, 1960.

Walser, Robert. *Microscripts*. Translated by Susan Bernofsky. New York: New Directions, 2012.

Woolf, Virginia. *Street Haunting and Other Essays*. London: Vintage Classics, 2014.

# ACKNOWLEDGMENTS

Thank you:

The ICON Conference for allowing me to do a lecture on doing nothing.

Bridget Watson Payne for asking me to turn said lecture into a book (this book).

Mirabelle Korn for editing this book.

Brooke Johnson for designing this book.

Peter Mendelsund for blurbing this book.

The San Francisco Public Library for lending me most of the books mentioned in this book, despite the long-outstanding $1.10 late fee.

Everyone mentioned in this book, for obvious reasons.

You the reader, for reading this book (unless you're a very peculiar kind of reader, the kind that ignores the body of the book and jumps straight to the acknowledgements page, perhaps with the motive of finding your name there).

Sophia Foster-Dimino, Daniel Levin Becker, Masha Kouznetsova, Ryan Sands, Helen Hancocks, Katrina Dodgson, Nicole Rudick, Joanna Walsh, Ivan Zhao, and my late cat Eustace, for their advice and expertise.